ABC ART RIDDLES

CAROL MURRAY

ILLUSTRATIONS BY
FREDDIE LEVIN

For Robert & Zack —
Happy Reading!
Carol Murray
— 2014 —

PEEL PRODUCTIONS INC.
COLUMBUS NC

To Max, for all his love and support.
-CM

To my high school art teacher, Mr. Wallie.
- FL

Published by Peel Productions, Inc.
PO Box 546, Columbus NC 28722
www.peelbooks.com

Printed & bound in China

Library of Congress Cataloging-in-Publication Data

Murray, Carol.
 ABC art riddles / by Carol Murray ; illustrations
by Freddie Levin.
 p. cm.
 ISBN 0-939217-58-9 (hardcover : alk. paper)
1. Art--Juvenile literature. 2. Riddles, Juvenile. I.
Title: Art riddles. II. Levin, Freddie, ill. III. Title.
 N7440.M87 2005
 709--dc22

 2005004444

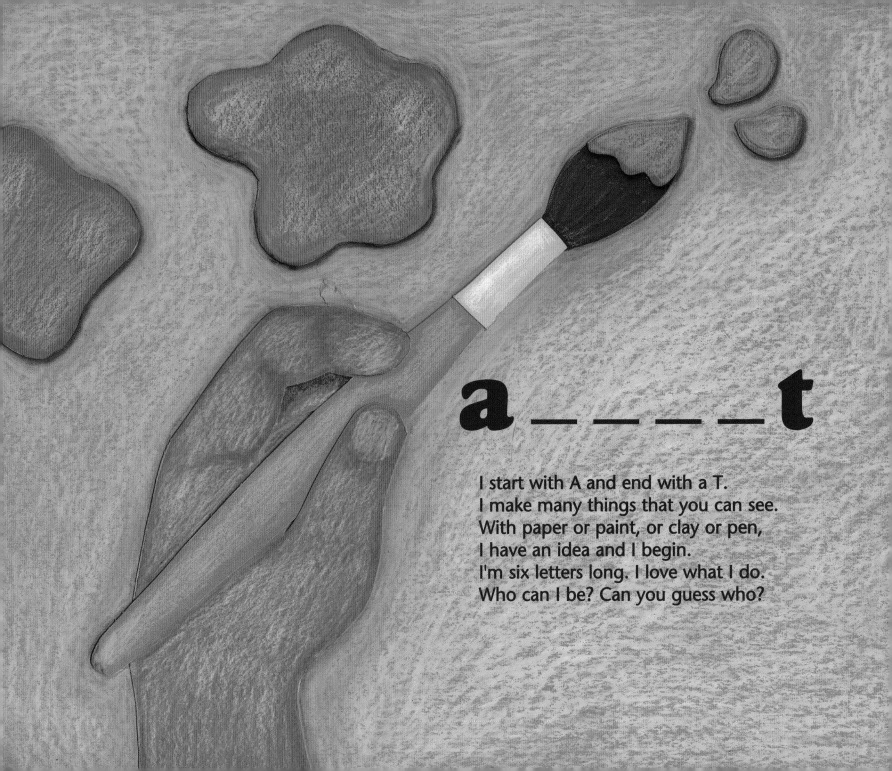

a _ _ _ _ _ t

I start with A and end with a T.
I make many things that you can see.
With paper or paint, or clay or pen,
I have an idea and I begin.
I'm six letters long. I love what I do.
Who can I be? Can you guess who?

b _ _ _ _ _

My name starts with B. I'm pointed and strong.
I'm used to place colors where they belong.
The artist protects me
and handles with care.
I'm covered with paint.
State my name, if you dare.

c _ _ _ _ n

A C starts my name. It ends with an N.
Found in a box, I can be fat or thin.
Any color you pick
is a colored wax stick.
I brighten your day.
What am I? Can you say?

d _ _ _

Beginning with D, I'm something you do,
when designing a castle, a boat, or a shoe.
A rocket or cow
can make you say, "Wow!"
Grab a pencil and start.
Can you guess? Aren't you smart!

e_ _ _ _ l

I start with an E and end with an L.
I'm useful for pictures and paintings, as well.
Your art will look grand
on my wooden stand.
I'm happy to hold.
What's you answer? Be Bold!

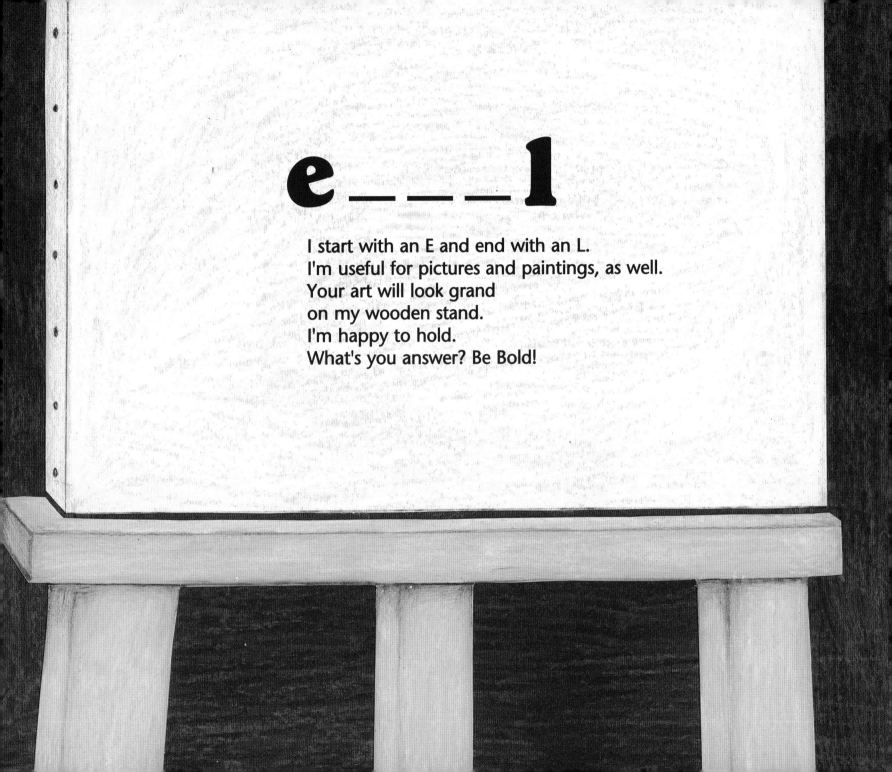

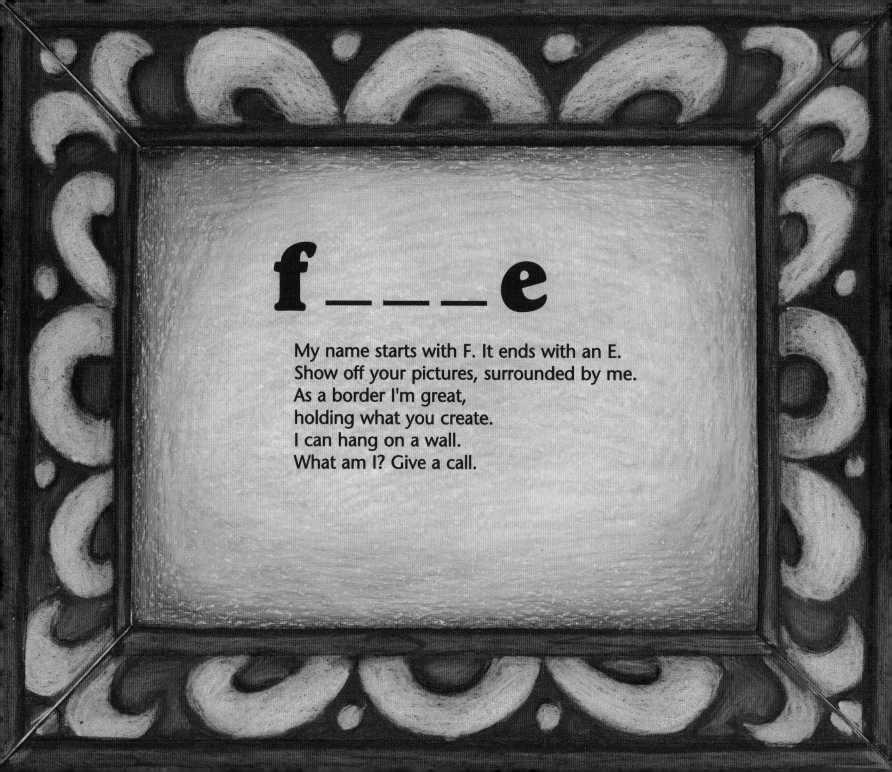

f____e

My name starts with F. It ends with an E.
Show off your pictures, surrounded by me.
As a border I'm great,
holding what you create.
I can hang on a wall.
What am I? Give a call.

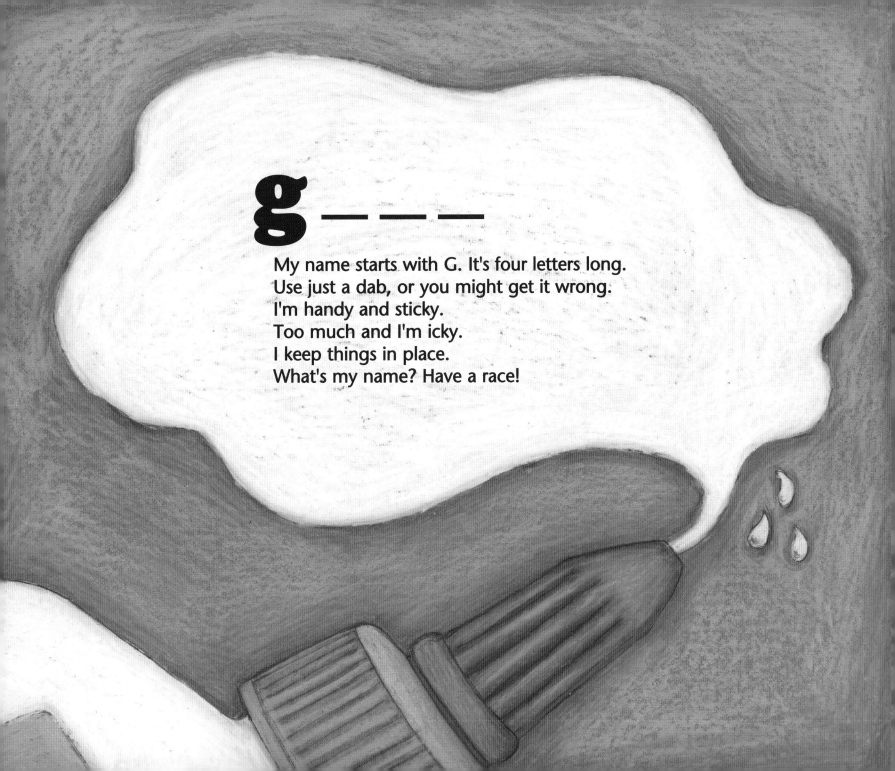

g _ _ _

My name starts with G. It's four letters long.
Use just a dab, or you might get it wrong.
I'm handy and sticky.
Too much and I'm icky.
I keep things in place.
What's my name? Have a race!

h _ _ _

I start with H. Sometimes I clap.
My fingers make a clever snap.
Use me to make all sorts of art.
Use me to throw a ball or dart.
You can make a print of me
for someone you love. What can I be?

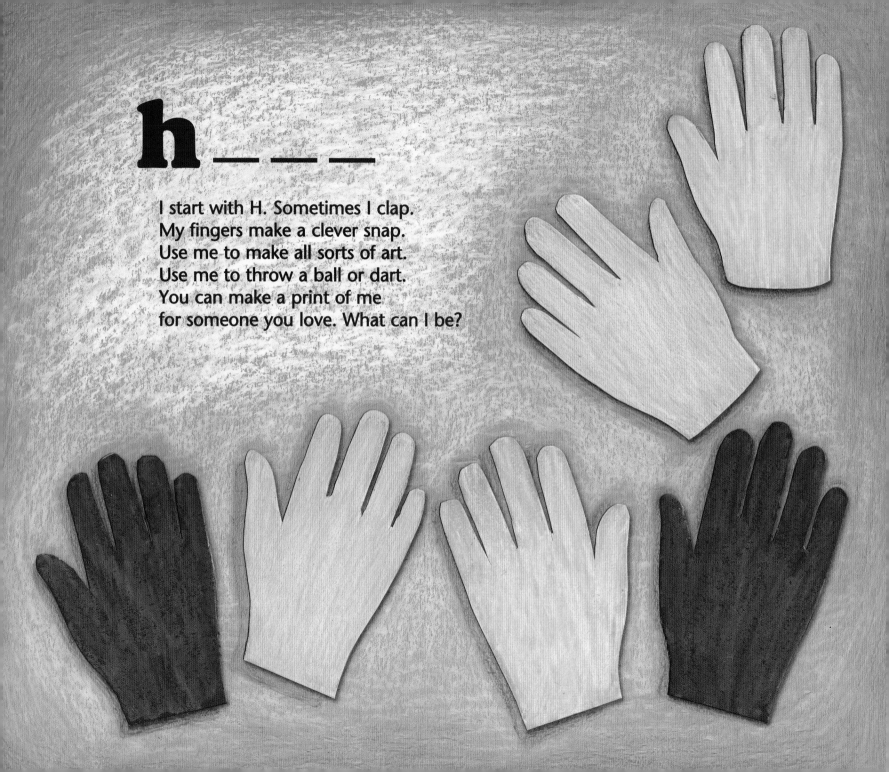

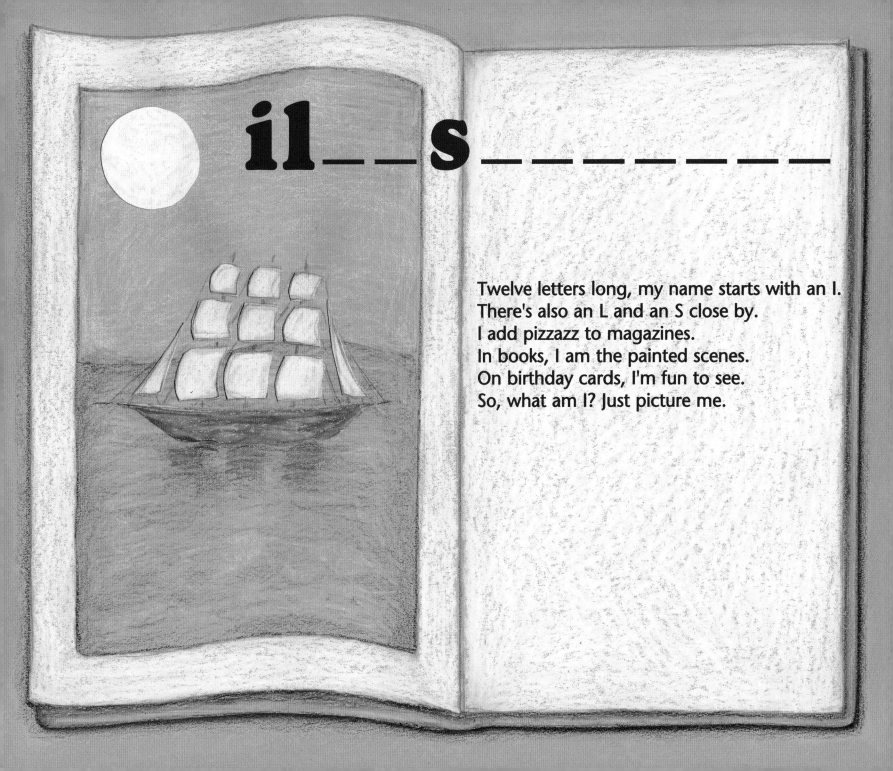

il___s_____

Twelve letters long, my name starts with an I.
There's also an L and an S close by.
I add pizzazz to magazines.
In books, I am the painted scenes.
On birthday cards, I'm fun to see.
So, what am I? Just picture me.

j __ k

I start with J and end with K.
I'm something someone throws away,
like broken glass or bits of wood,
a rusty wire, a metal hood.
Some say I'm trash, but artists see
a treasure chest. What can I be?

k _ _ n

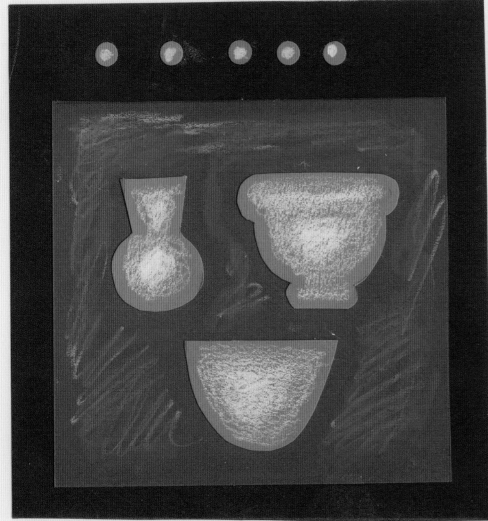

A little word, I start with K
and end with N. I bake your clay.
I'm perfect when I'm very hot,
to glaze a vase or bake a pot.
Ceramic artists know me well.
What's your answer? Can you tell?

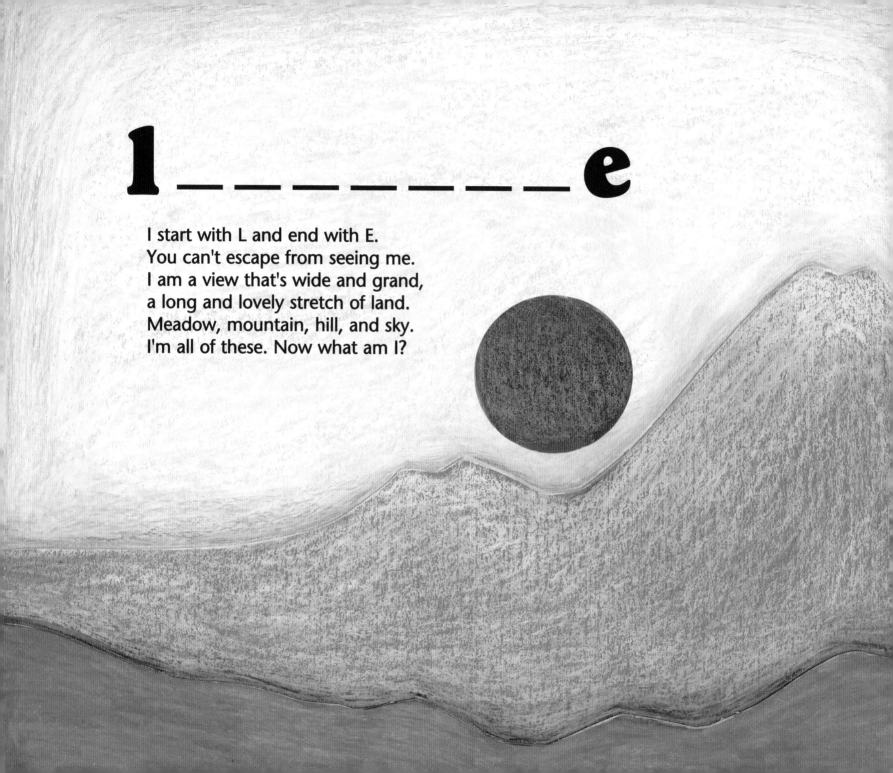

l_____e

I start with L and end with E.
You can't escape from seeing me.
I am a view that's wide and grand,
a long and lovely stretch of land.
Meadow, mountain, hill, and sky.
I'm all of these. Now what am I?

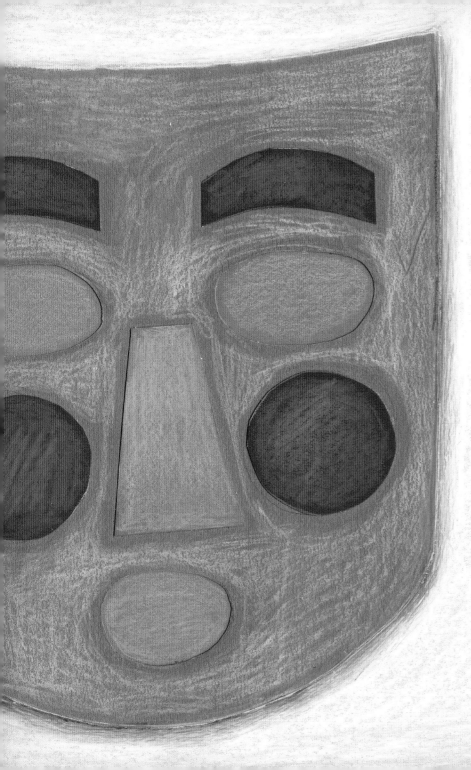

m _ _ _

M starts my name. I'm something you wear
to cover your face, or to look like a bear.
My shapes and my sizes
make clever disguises.
I'm fun to create.
What's my name? Can you state?

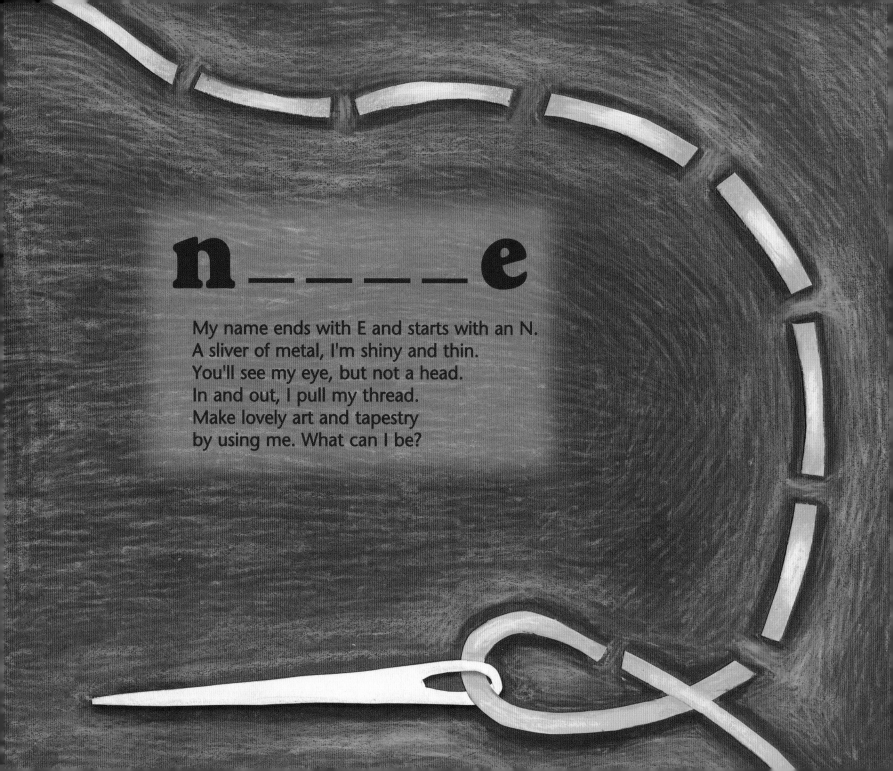

n_____e

My name ends with E and starts with an N.
A sliver of metal, I'm shiny and thin.
You'll see my eye, but not a head.
In and out, I pull my thread.
Make lovely art and tapestry
by using me. What can I be?

o - - - - - - - - - - - - i

I end with I and start with O.
By folding paper, neat and slow,
you can make a silly hat,
a sailboat, or a monster cat.
I'm fun to do. I'm Japanese.
What am I? Your answer, please.

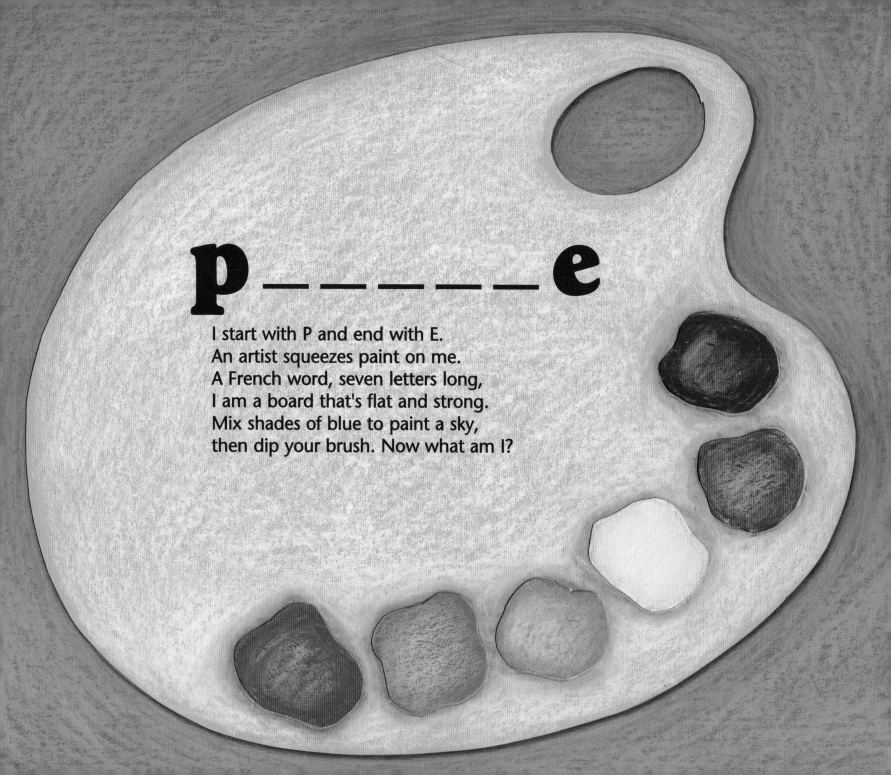

p_____e

I start with P and end with E.
An artist squeezes paint on me.
A French word, seven letters long,
I am a board that's flat and strong.
Mix shades of blue to paint a sky,
then dip your brush. Now what am I?

q — — — — — — —

Q in the second letter in my name.
There are five more letters, none are the same.
Four right angles are part of me.
I am a shape you often see.
My sides are equal, always straight.
What's my name? Don't hesitate.

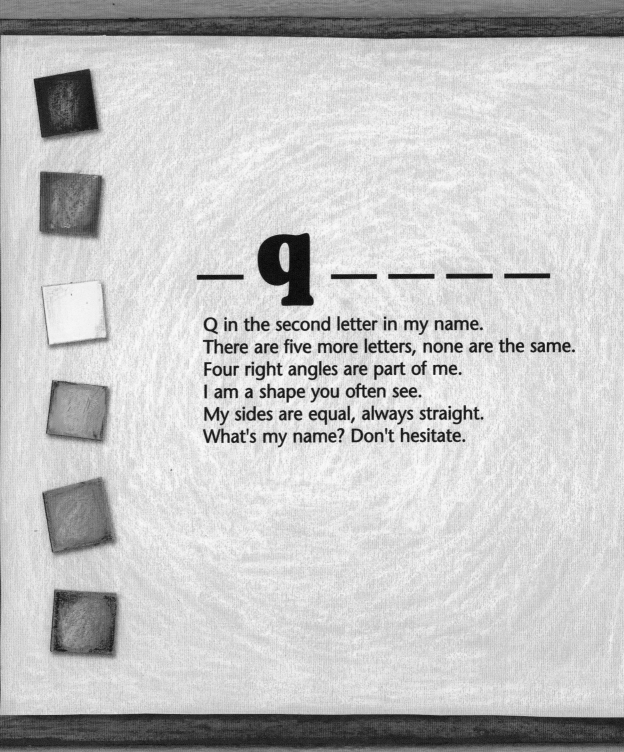

r_____t

My name starts with R and ends with T.
To make a design, artists use me.
My word means "again and again, and again."
Use me on paper, or cloth, or on tin.
Over and over, inch by inch,
Can you guess? My name's a cinch!

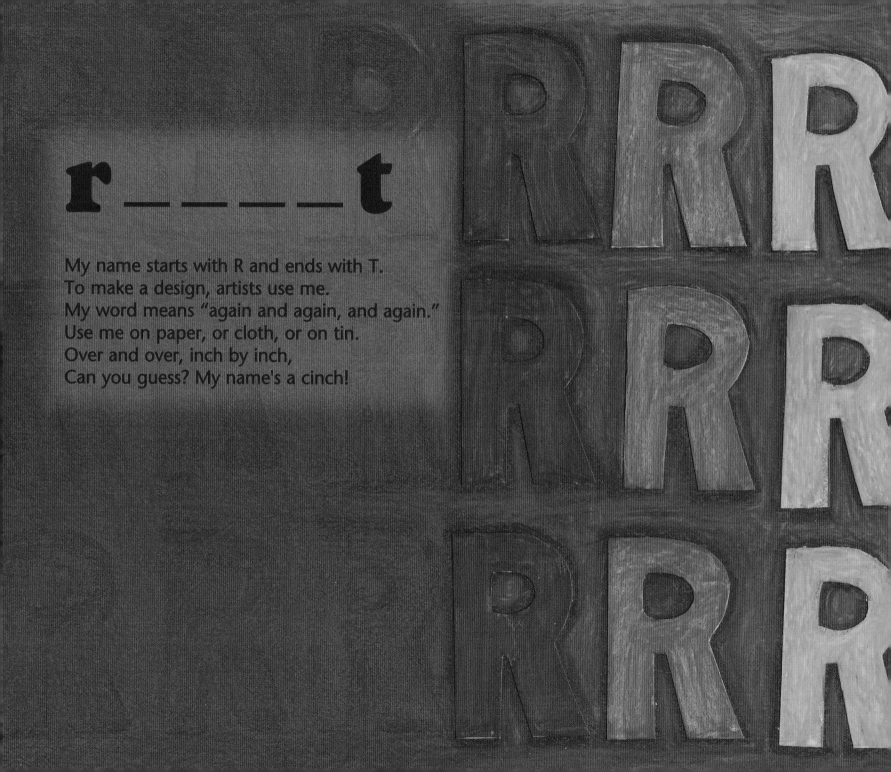

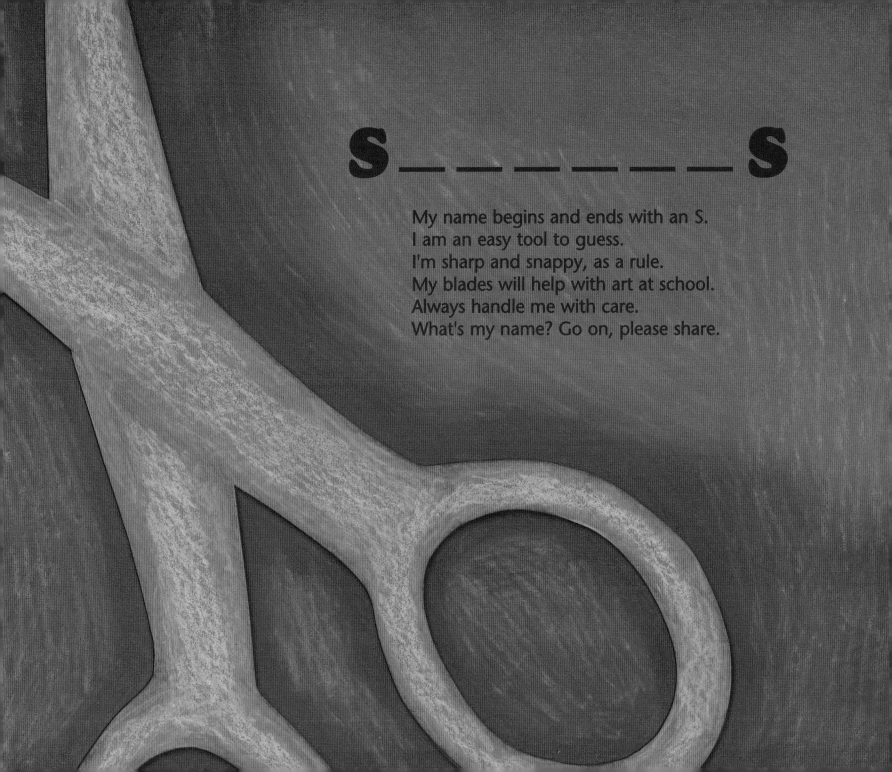

S_____S

My name begins and ends with an S.
I am an easy tool to guess.
I'm sharp and snappy, as a rule.
My blades will help with art at school.
Always handle me with care.
What's my name? Go on, please share.

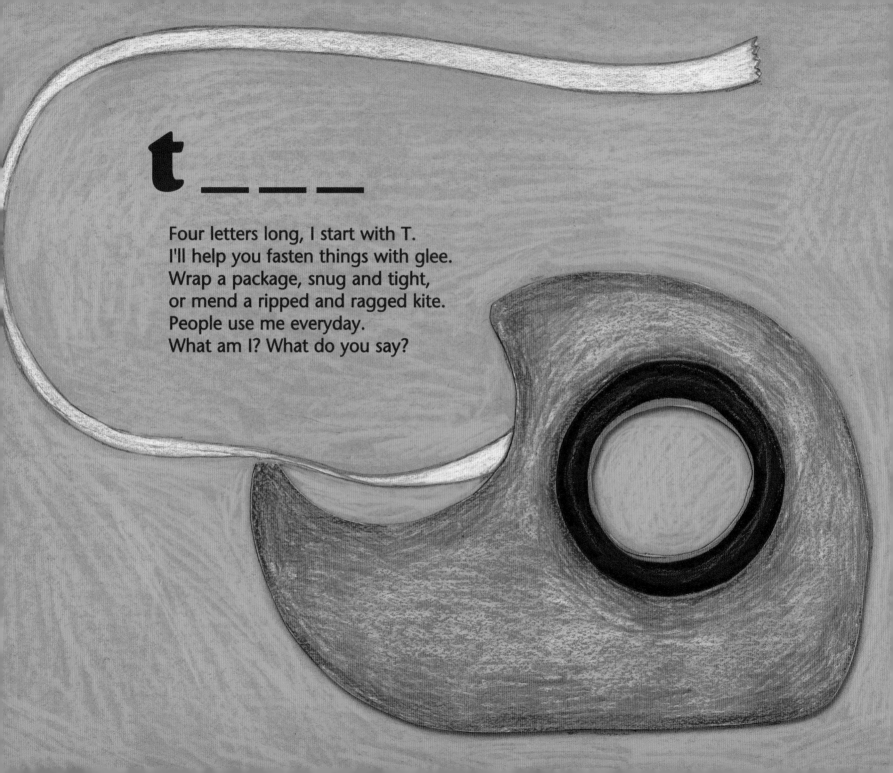

t _ _ _

Four letters long, I start with T.
I'll help you fasten things with glee.
Wrap a package, snug and tight,
or mend a ripped and ragged kite.
People use me everyday.
What am I? What do you say?

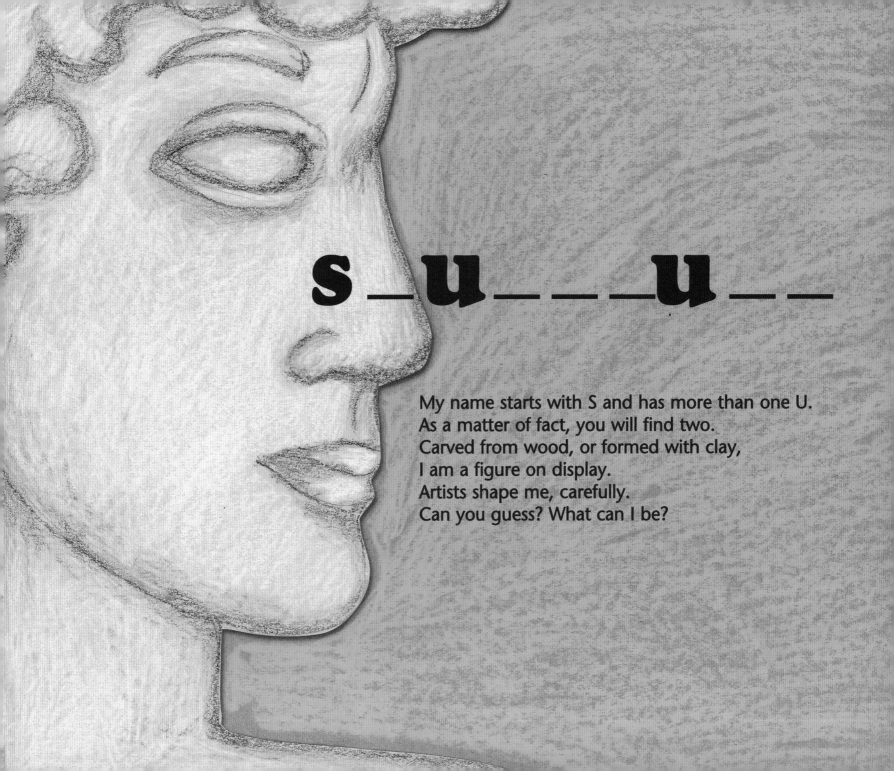

s _ _ u _ _ _ _ u _ _

My name starts with S and has more than one U.
As a matter of fact, you will find two.
Carved from wood, or formed with clay,
I am a figure on display.
Artists shape me, carefully.
Can you guess? What can I be?

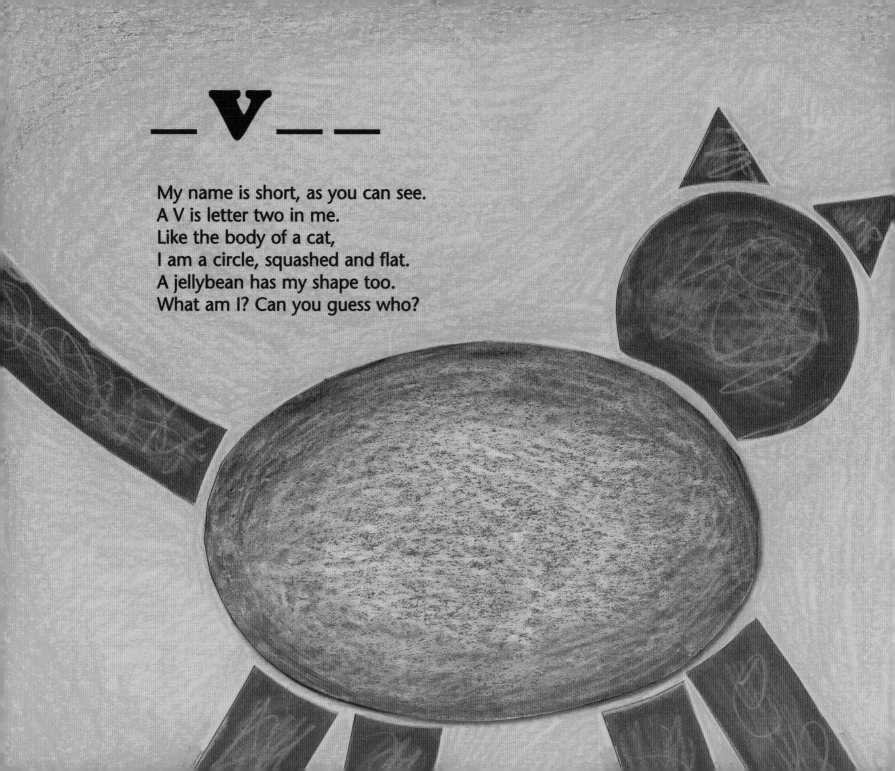

_ V _ _ _

My name is short, as you can see.
A V is letter two in me.
Like the body of a cat,
I am a circle, squashed and flat.
A jellybean has my shape too.
What am I? Can you guess who?

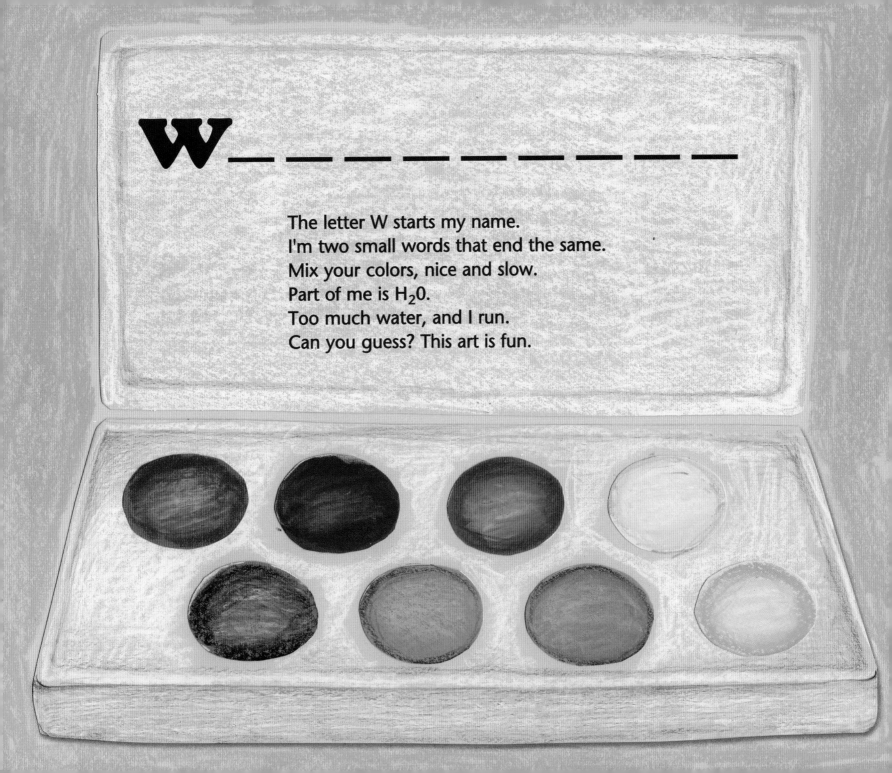

W _ _ _ _ _ _ _ _ _ _

The letter W starts my name.
I'm two small words that end the same.
Mix your colors, nice and slow.
Part of me is H_2O.
Too much water, and I run.
Can you guess? This art is fun.

t_x_ _ _ _ _

I have an X inside of me,
but truthfully, I start with T.
Feel my surface with your hand.
Smooth as satin? Rough as sand?
Look and you can also see.
Rough? Smooth? What can I be?

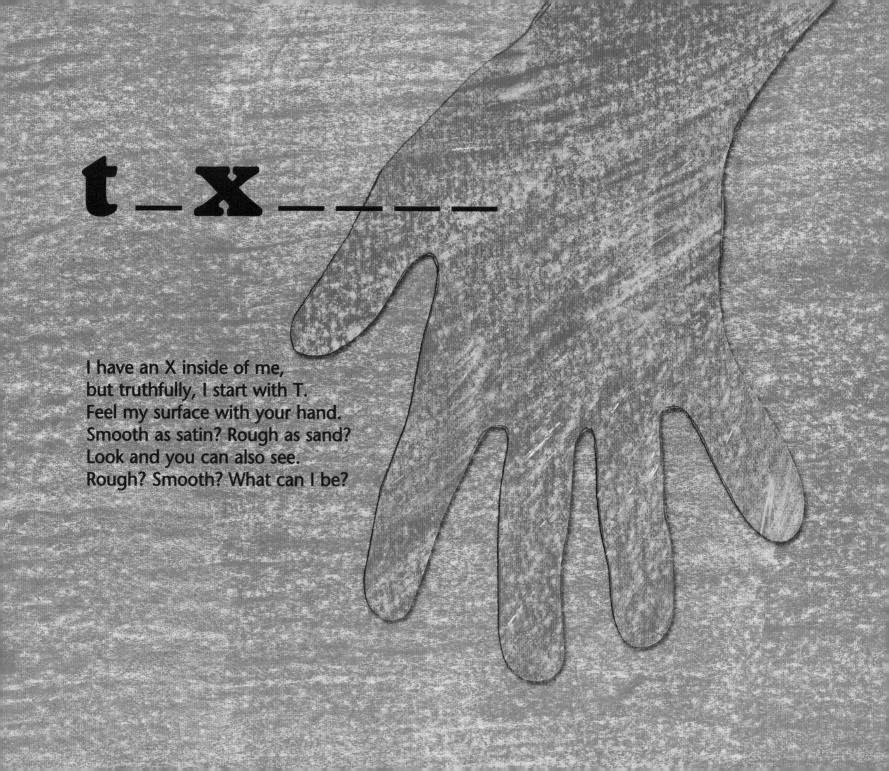

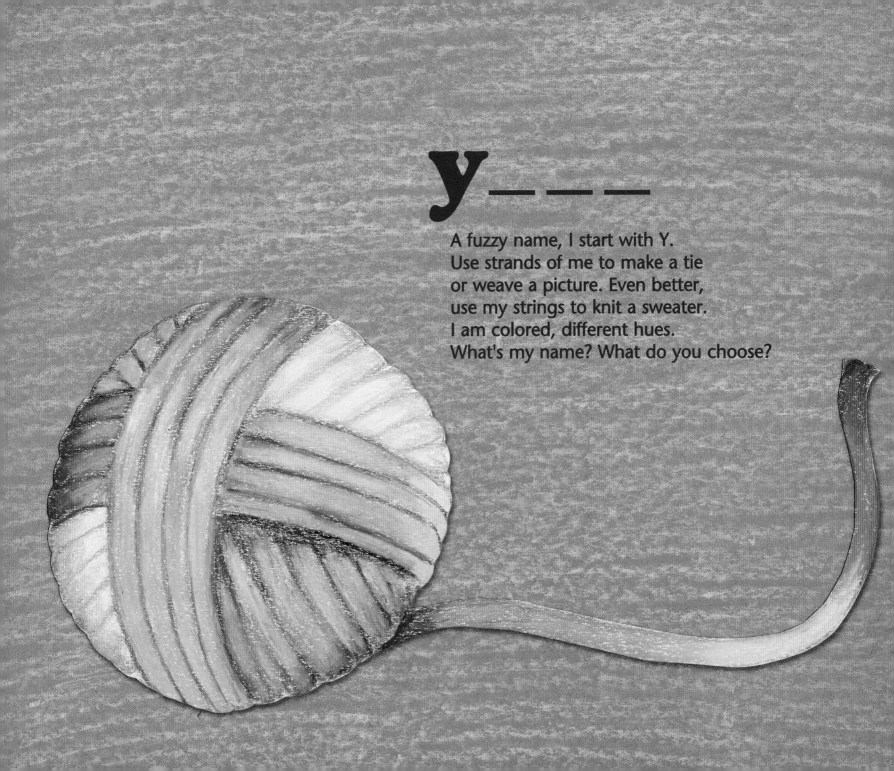

y_ _ _

A fuzzy name, I start with Y.
Use strands of me to make a tie
or weave a picture. Even better,
use my strings to knit a sweater.
I am colored, different hues.
What's my name? What do you choose?

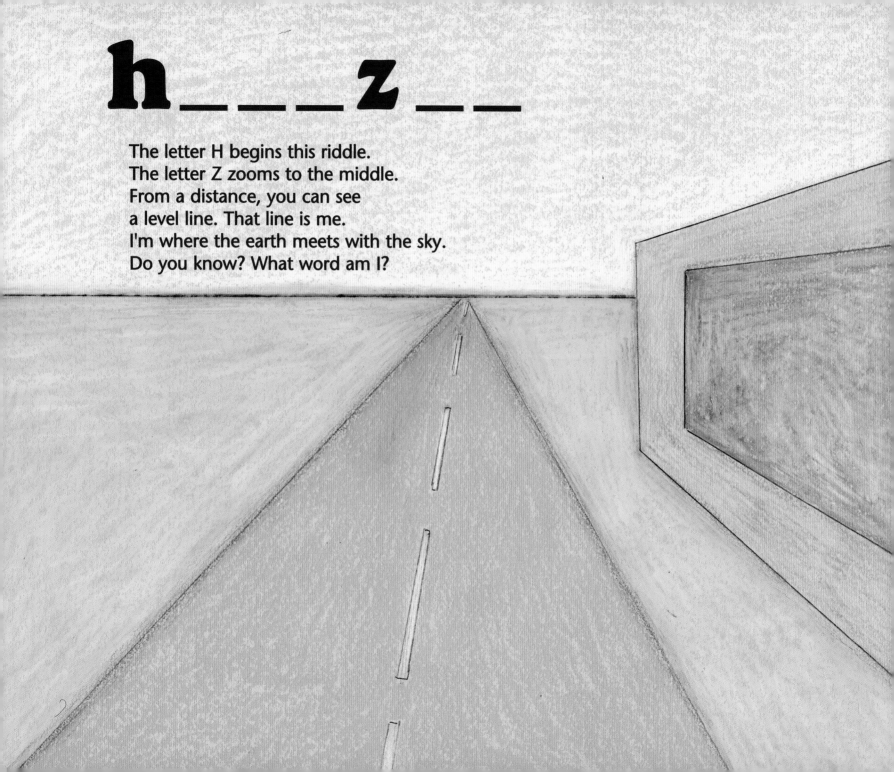

h _ _ _ _ z _ _

The letter H begins this riddle.
The letter Z zooms to the middle.
From a distance, you can see
a level line. That line is me.
I'm where the earth meets with the sky.
Do you know? What word am I?

a＿＿＿＿＿s

We start with an A and end with an S.
We say what's correct. What did you guess?

artist	needle
brush	origami
crayon	palette
draw	square
easel	repeat
frame	scissors
glue	tape
hand	sculpture
illustration	oval
junk	watercolor
kiln	texture
landscape	yarn
mask	horizontal

Ideas for Parents and Teachers

- Instruct children to wait until all clues have been given before guessing the riddle. Have the child who guesses the answer first say the correct word, spell it out, then choose a new art riddle to read.

- Make up additional *ABC Art Riddles*. Let children choose something about which they are curious. Begin with letter and word clues. Look up definitions in the dictionary to make sure children use the just-right words. Instruct them to pay attention to the rhythm as well as the rhymes. End each riddle with a question, inviting others to answer the riddle.

 Start with a simple riddle such as this one for pencil:

 > *I start with a P and end with an L.*
 > *Use me to draw a giraffe or a snail.*

- Choose a riddle that children found hard and make it easier, or select one they found easy and make it harder! Instruct them to write a couple of lines (a couplet) to add another clue.

- Encourage children to draw or sculpt the subjects of a riddle. For ideas, look for art concepts and shapes at school, at home, in the city, in the country, in the arts, and in nature.

- Share riddles and illustrations! Perform them in front of others.

 Creating riddles that rhyme is a wonderful way to explore art words and ideas. As you engage children personally in the poetic process, you will see them blossom in their vocabulary, their understanding of words and their meanings.

 Have Fun!

a _ _

I'm something you make. I start with an A.
Build me with sticks, or with papier mache.
Use pencil or stencil,
or crayon, or clay,
AND your imagination.
What am I? Can you say?

If you've enjoyed this book, look for others
on our web site

http://peelbooks.com

or at your favorite bookseller